Scott Baxter's Arizona
LIFE ON THE RANGE

ARIZONA
HIGHWAYS

Photographs: SCOTT BAXTER
Editor: KELLY VAUGHN
Designer: BARBARA GLYNN DENNEY
Copy Editor: NOAH AUSTIN
Photo Editor: JEFF KIDA

ISBN: 978-0-9987893-0-9
First printing, 2017. Second printing, 2018. Printed in Canada.

Published by the Book Division of *Arizona Highways* magazine,
a monthly publication of the Arizona Department of Transportation,
2039 W. Lewis Avenue, Phoenix, Arizona, 85009.

Telephone: 602-712-2200

Website: www.arizonahighways.com

Publisher: Win Holden
Associate Publisher: Kelly Mero
Editor: Robert Stieve
Senior Editor/Books: Kelly Vaughn
Associate Editor: Noah Austin
Creative Director: Barbara Glynn Denney
Art Director: Keith Whitney
Photography Editor: Jeff Kida
Editorial Administrator: Nikki Kimbel
Production Director: Michael Bianchi
Production Coordinator: Annette Phares

BRENT CLINE
WITH BEAR *(cover)*

"This was made at the Cline Ranch in
Gila County," says photographer Scott
Baxter. "It's a special image because
Bear, Cline's best horse, died of
colic about a week after this." Cline
is wearing batwing chaps, an Arizo-
na-New Mexico style, Baxter adds.

MY PROCESS IS SIMPLE. I keep my equipment basic, and my approach to a photograph is grounded in the emotion present in the scene. Keeping things straightforward and as honest as possible seems to drive the narrative of my photographs. If I push too hard or try to force an image, it doesn't work for me. If I allow the photograph and subject to come to me naturally, then I feel like I've done my job. Sometimes, you just need to remember it's not only about the pictures — it's also about the experience.

The spirit of the West is intrinsically linked to the American cowboy. Among sweeping vistas and big skies, you find the Arizona cowboy — the cowpuncher — accompanied by a fine horse and a true sense of freedom few of us ever realize. It's often easy to become swept up in the grandeur and startling scale of the West, so when photographing cowboys, I try to remember why I'm there. I feel the need to stay grounded and work with purpose, so that I can attempt to bring the same sense of honesty and integrity that my subjects live every day. The tradition of the cowboy endures, even though progress swirls and seems to swallow whole so many facets of the traditions of the American West.

The best critics of my work have always been the cowboys. Learning the nuances of their jobs and lifestyles can make or break your image. Is the horse moving correctly, with a good tail set? Is the knot right on the cowboy's wild rag? Why is fixing fences a never-ending job? Years of asking questions, making mistakes and quietly observing are just part of the deal. I have to put time into the process, so that my photography does justice to my subjects and the range they ride.

Before picking up a camera, I always take the time to know these people, their families and their history. I find out why riding the "outside circle" is all they ever wanted to do. The photograph is just the end result of the story.

— *Scott Baxter*
PHOENIX, ARIZONA, 2017

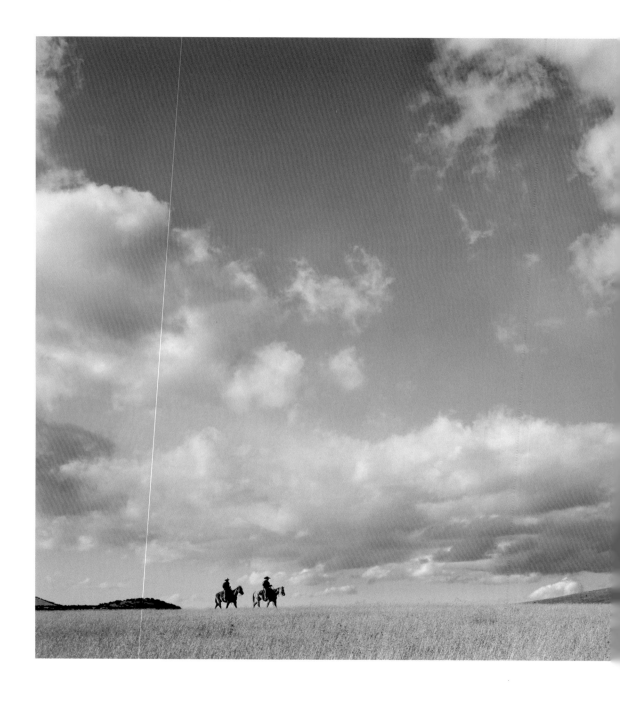

Scott Baxter frequently photographs this pasture, at the X Diamond Ranch in Apache County. He made this image of Cody Cunningham (right) and his protégé, Tanner Lund, in November 2014. Cunningham rides his gray horse, Blue, while Lund rides a grulla horse named Grulla.

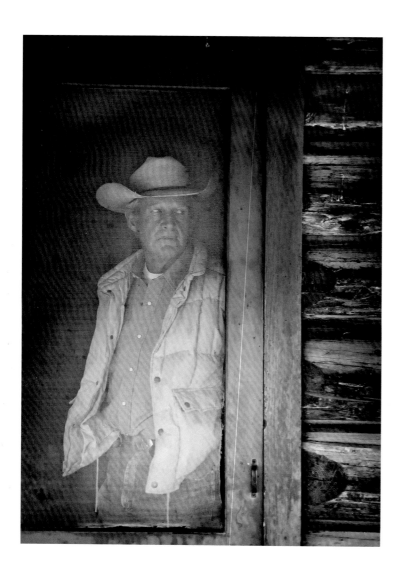

SAM UDALL

This cabin at Voight Camp (left), part of the X Diamond and MLY ranches, is owned by the U.S. Forest Service and was built in the 1920s. "Sam was the very first cowboy I photographed," Baxter says. "I think I met him in 1997 or 1998, but this photograph is probably 2006. This particular day, Sam was with my friend Joe Hall, from Montana. The two of them were spinning stories."

SPRING GATHER

"I photographed the spring gather (right) at the Sierra Bonita Ranch in May 2011," Baxter says. "The cowboy, Leslie Shannon, is dragging the calf to be branded." The ranch, located in Cochise and Graham counties, uses traditional methods of branding with irons in a fire, Baxter adds. Throughout the day, cowboys rotate through responsibilities.

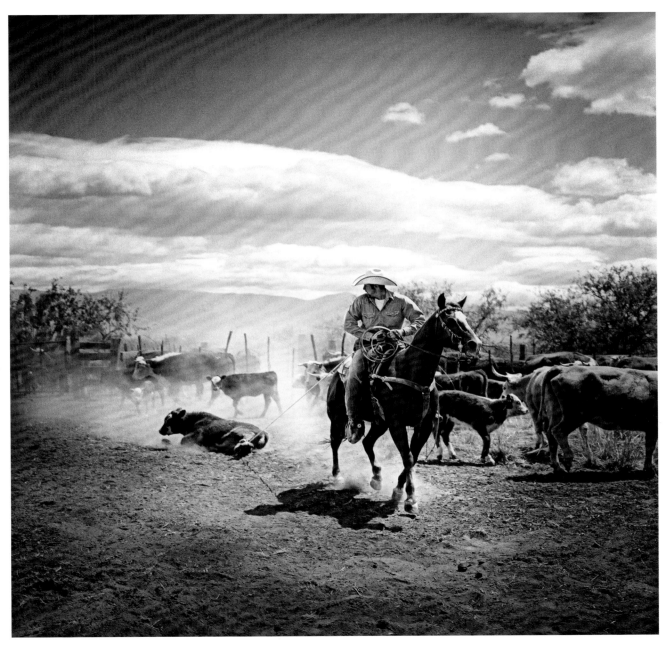

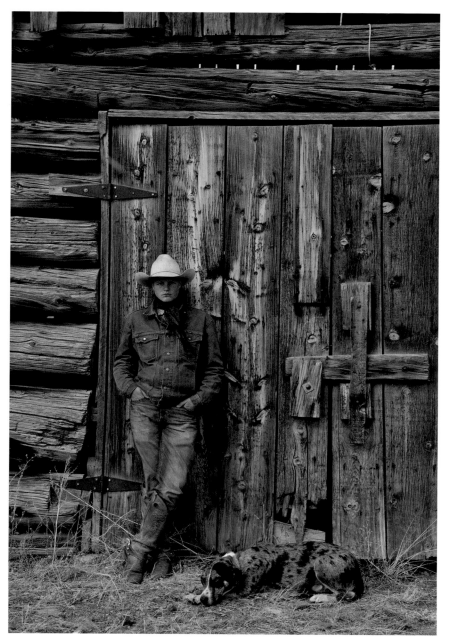

TANNER LUND

This portrait of Tanner Lund was made in Eagar when Lund was Cody Cunningham's protégé at the X Diamond Ranch. Here, he rests with Cunningham's Catahoula leopard dog, Chomp. "Tanner's starting some colts now," Baxter says. "Pretty good for a young kid."

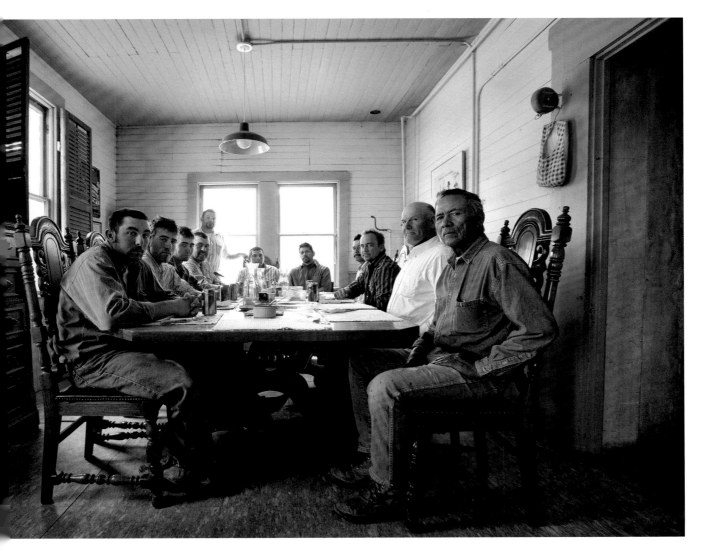

NOONTIME

At the Sierra Bonita Ranch in Graham and Cochise counties, it's traditional for the cowboys to have lunch together anytime there's a gathering or roundup. Jesse Hooker Davis, whose family has ranched in Arizona since 1872, stands at the back left of this image. His ranch manager of 40 years, José Adame, is seated at the front right. "Thick adobe walls were built to protect this ranch house from attacks by Apaches," Baxter says. "There's a room on one end where Doc Holliday and Wyatt Earp used to hang out."

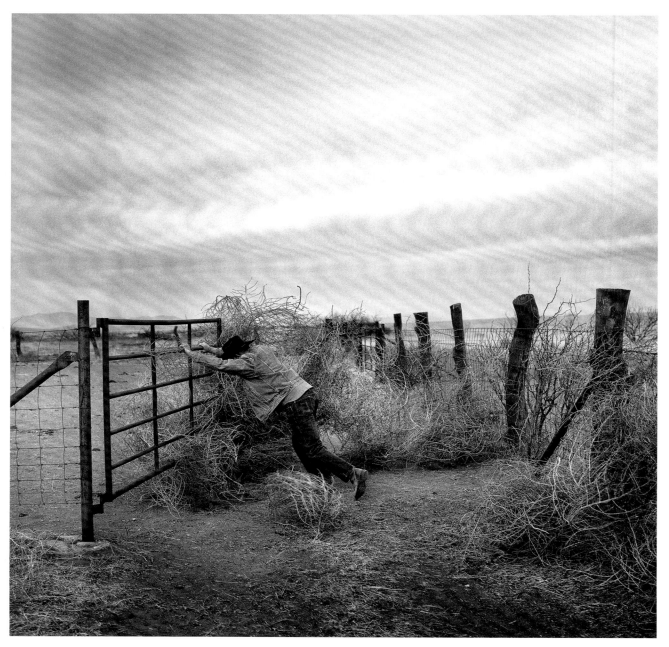

JIM RIGGS

"There are enough members of the Riggs family in ranching that you could do the whole book on the family," Baxter says of this photograph (left) of Jim Riggs at the Cross J Ranch in the Chiricahua Mountains. "This was February, and it was cold, cloudy and drizzly. The wind had blown tumbleweeds behind this gate, so Jim had to push it open."

VINSON PICOZZI

Vinson Picozzi (right), a sixth-generation rancher, has a significant family legacy. "Vinson, of the MLY and X Diamond ranches in Apache County, was named for Vince Butler, his great-great-grandfather and the patriarch of the MLY and X Diamond ranches," Baxter says. "MLY is the Molly Butler brand."

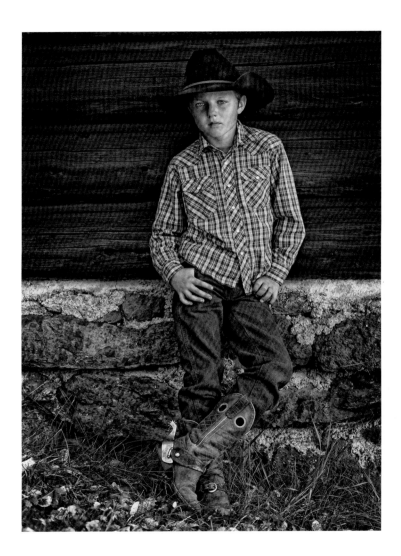

SOUTH FORK, LITTLE COLORADO RIVER

This photograph was made one November afternoon when winds reached 56 mph. "It was bitter cold," Baxter says. "Tanner Lund (left) and Cody Cunningham are out looking for cows. This is right at the headwaters of the South Fork of the Little Colorado River."

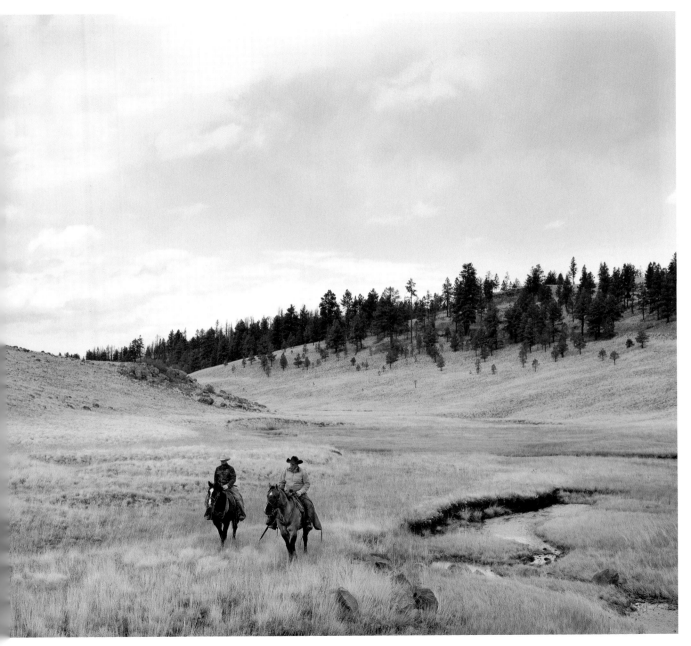

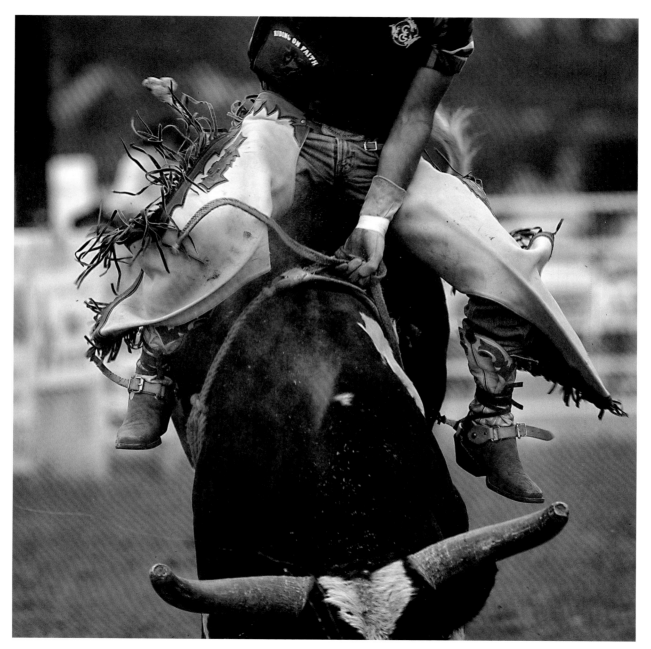

EAGAR RODEO

"This is an old photograph (left), taken in 2004 or 2006," Baxter says. "There were these 21-year-old kids on a really small rodeo circuit. I liked this shot because of the 'Riding on Faith.' Sometimes with rodeo images, I try to shoot a little bit differently than what's traditional. Sometimes, it might be as simple as changing the crop."

SUNEE'S SPUR

Sunee RomanNose (right), a contract cowboy at the Hacienda Amado in Santa Cruz County, wears boar-hide chaps and Paul Bond boots in this photograph. "Sunee and I were having lunch together when I shot this," Baxter says.

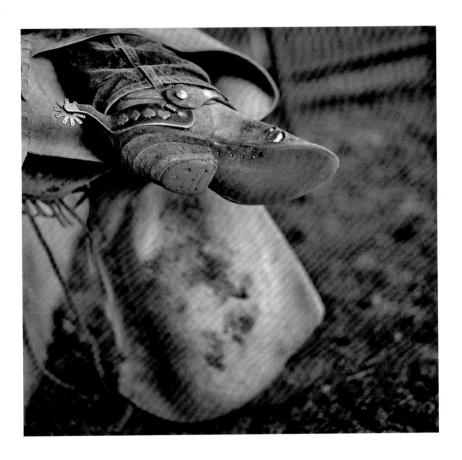

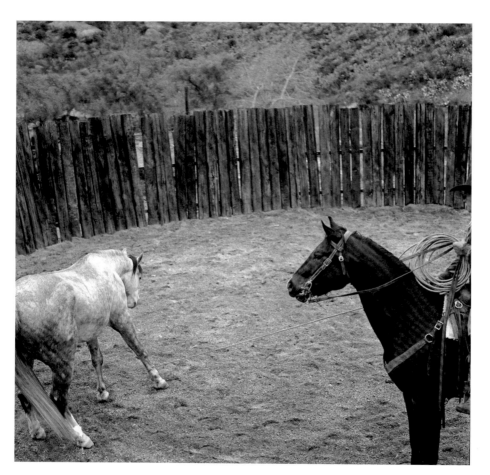

THE ROUND PEN

Newell Dryden (left) of Black Rock Ranch in Graham County gentles a horse in this photograph. "This was late March of 2011," Baxter says. "It was very cold, like 37 degrees. Prior to this, Newell was in an accident that injured his back. He'd need help to get on his horse, but once he did, he was good to go."

BRANDING

Jesse Hooker Davis (right) brands a calf at the Sierra Bonita Ranch. "This just laid out right for me." Baxter says. "Sometimes it just has to work out right, because with a Hasselblad, I'm not shooting very quickly. I'm almost like a boxer, sticking and moving. I pick my spot and go back in my memory to predict what's about to happen. Then there's a time when I say, 'Now. Do it now.'"

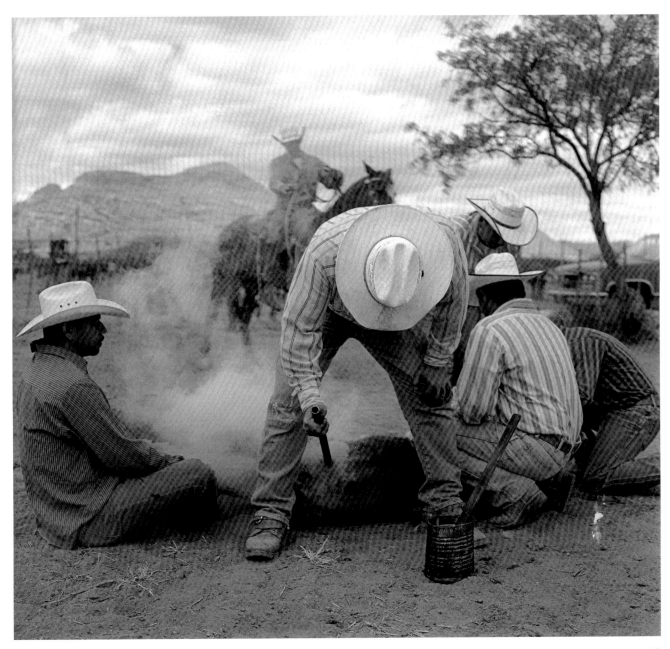

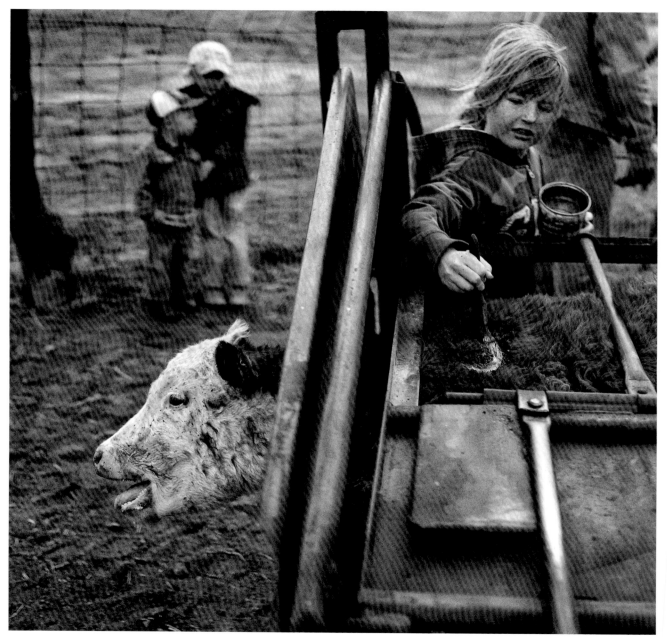

ASHLEY RIGGS

When this photograph (left) of Ashley Riggs — of the Cross J Ranch southeast of Willcox — was made, Riggs was just 10 years old. "She was babysitting the whole day, but when we started moving around, she got out of the truck and opened every gate," Baxter says. "The next day, she was out putting air in the stock trailer's tires at 6 a.m." Here, Riggs applies a salve to a recently branded calf.

DAY WORKER

Clayton Hill (right), a day worker at the Sierra Bonita Ranch, walks away from a conversation with Jesse Hooker Davis in this portrait. "This is just another one of those devastatingly handsome cowboys," Baxter says.

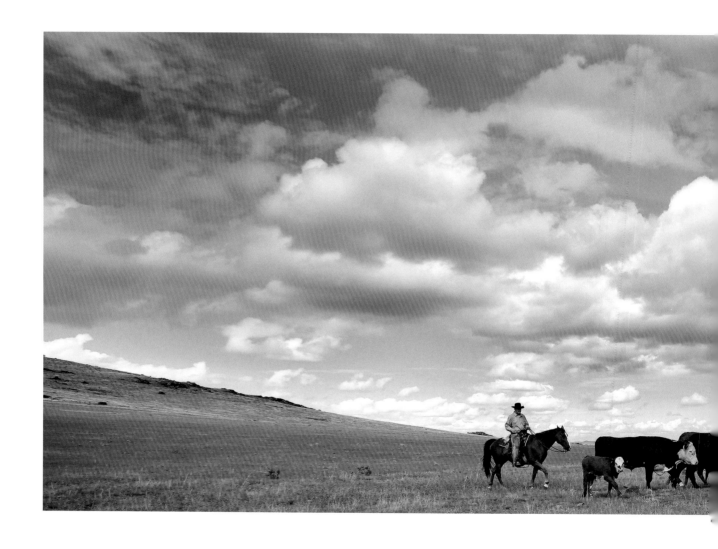

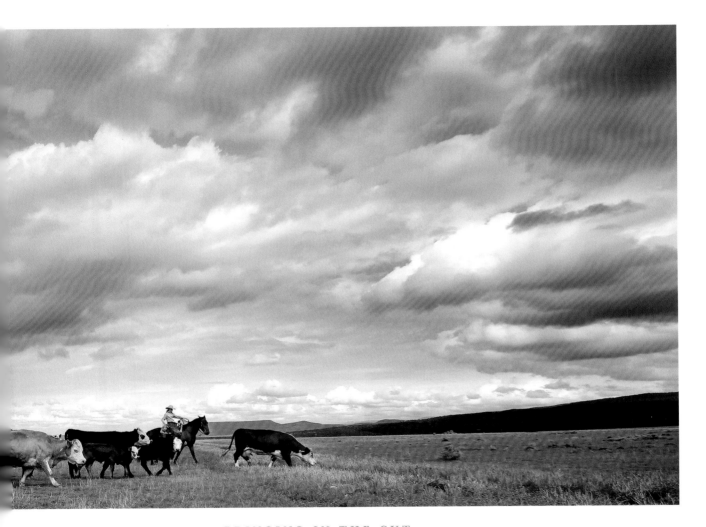

BRINGING IN THE CUT

The photographer's daughter, Lily Baxter, rides with Sam Udall in the Windmill Pasture at the X Diamond Ranch in this image from 2006. "This is called 'bringing in the cut,' just moving a small number of cows," Baxter says. "Lily was learning to do cow work there."

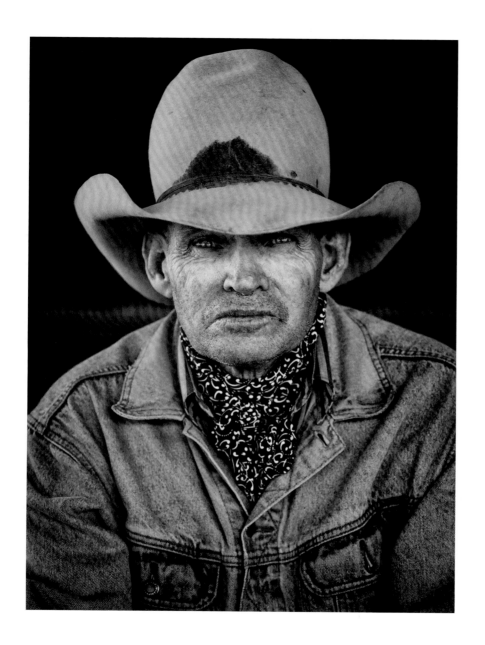

ANDY ZEIGLER

Andy Zeigler cowboys for Sam Donaldson at the Rosemont Ranch in Pima County. "Andy is a very quiet man," Baxter says. "I was drawn to his eyes and his hat. This photograph was shot in available light in the hay barn at the ranch. He came and sat with me for 45 minutes or an hour. This portrait was more about getting to know him."

LILY BAXTER

The photographer's daughter wears his hat and shirt in this portrait, made at Cattletrack in Scottsdale. "When Lily was little, I'd send her to spend time with Kym Johnson at the MLY Ranch," Baxter says. "She'd wake up at 4 a.m., do chores, learn to be polite and ride horses all day. Lily's introduction to horses was through Kym. Eventually, Lily started doing team penning and team sorting. Her reining horse lives with me now."

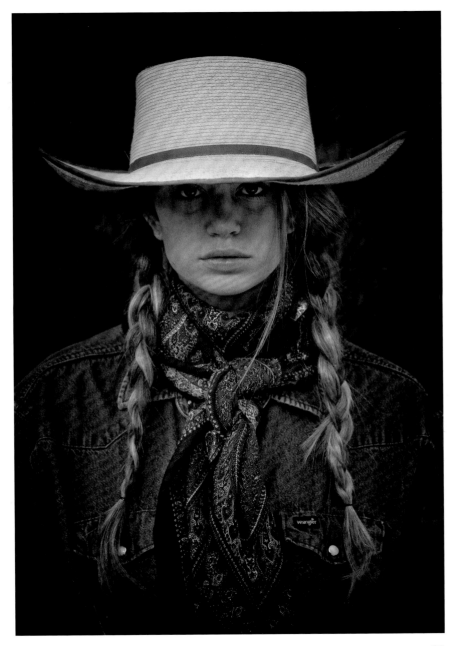

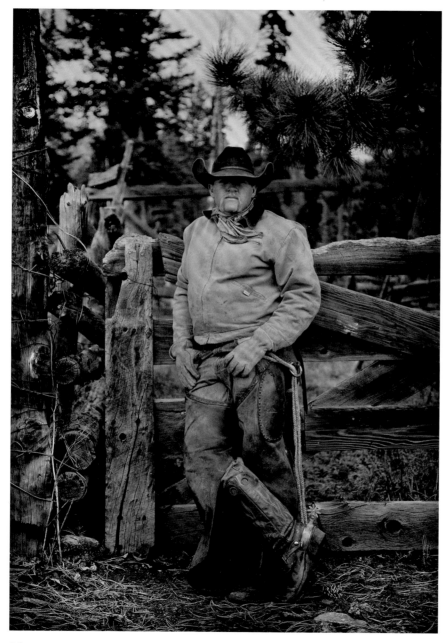

CODY CUNNINGHAM

Baxter made this portrait of Cody Cunningham at the Burro Creek corrals in Apache County, near the West Fork of the Black River. "It was a windy November day — just cold, cold, cold at these old corrals," Baxter says. "Cody is from West Texas. He's an honorable man."

SHEILA CARSON

"I photographed Sheila for the first time in January at the Flying M Ranch in Coconino County," Baxter says. "It was cold, and she wore a felt hat. In every single negative from that shoot. there was an inexplicable flare. Her longtime companion had passed away not long before I photographed her. We decided that the flares were because he hated that felt hat, but he loved her in this palm hat.'

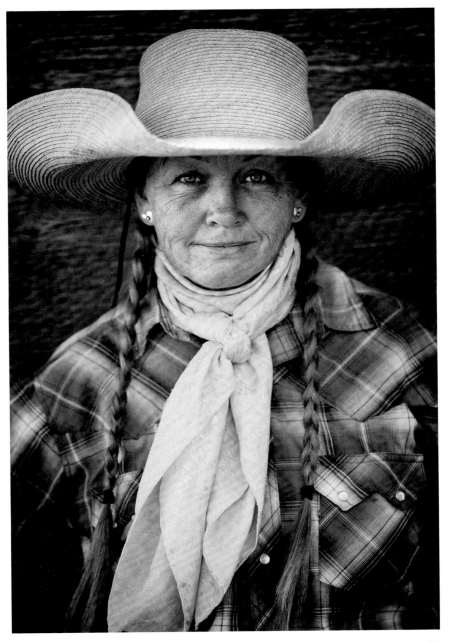

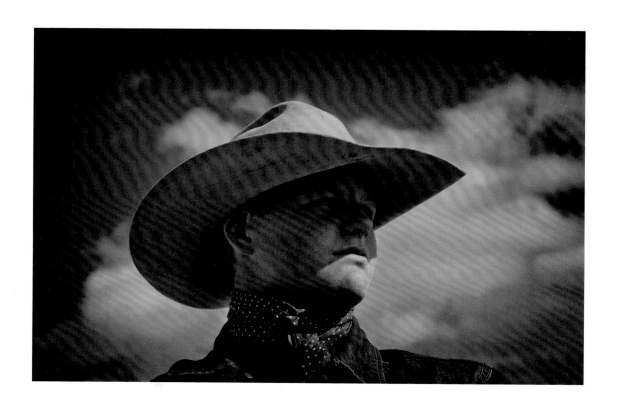

TANNER LUND

These portraits were shot in two different areas on the same trip. Baxter made the photograph at right in Schoolhouse Pasture on the X Diamond Ranch. He photographed Lund for the portrait at left along the South Fork of the Black River. "I was having him and Cody [Cunningham] go out," Baxter says. "I told them what I wanted to do. The wind was so strong, I don't know how he kept his hat on. There is a mentoring system at many of these places, and Tanner has done them well. He doesn't want to be a rodeo cowboy — he wants to be a cowboy."

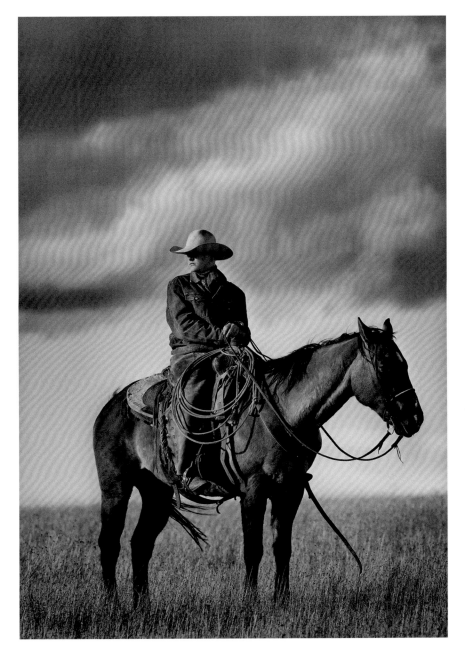

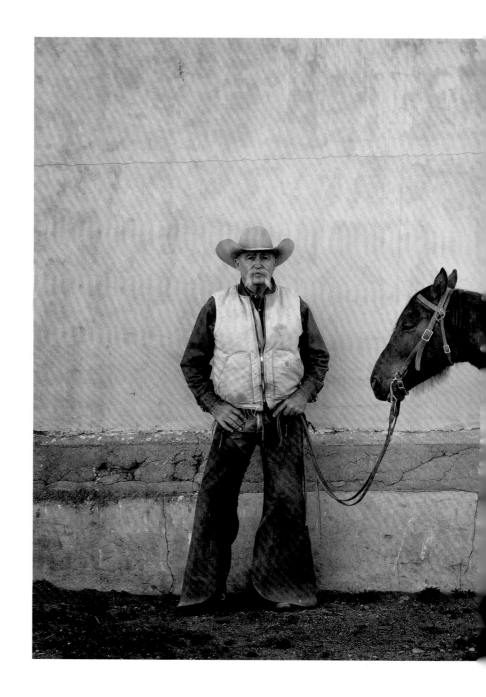

MATT FORD

"This is Matt Ford, a Southern Arizona contract cowboy, at the Sierra Bonita Ranch," Baxter says. "And this is the original adobe wall that Colonel Thomas Hooker built to keep the Apaches at bay."

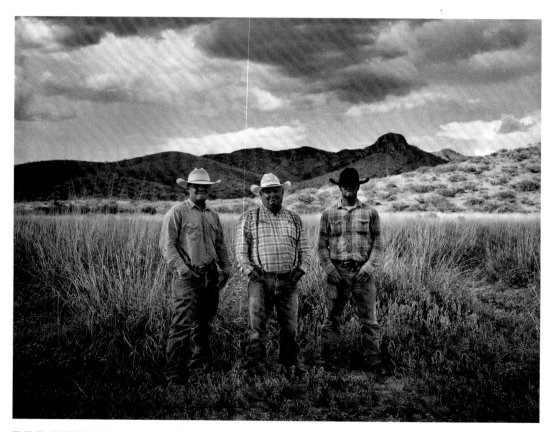

THE KRENTZ FAMILY

Rob Krentz is missing from this image — the rancher was murdered along the U.S.-Mexico border in 2010. A year later, Baxter made a portrait of Krentz's son, brother and nephew in the Oso Pasture in Cochise County. They are Frank, Phil and Ben Krentz, respectively. "This is the last photograph from my *100 Years 100 Ranchers* project," Baxter says. "Rob's wife, Sue, was standing next to me, crying. It was very emotional. It was hot and sticky — August 2011. When I pulled in off the highway, it rained in a 100-square-foot area for a minute, then that rain moved on."

JERRY VOJNIC

Jerry Vojnic's mother is Silkie Perkins of the Dave Perkins Ranch in Jerome. And, according to Baxter, Vojnic wasn't scheduled to be at the shoot that day. "We got down to the spot where I was going to photograph Silkie, and there was a kid on a white horse," Baxter remembers. "The kid's bareback on it. That morning, Silkie told Jerry to have that horse to the pasture by 2 p.m. She said she'd have her saddle and would ride for the shoot. Jerry rode bareback 12 miles and had to open and close a bunch of gates. After the shoot, they just turned the horse out in the pasture."

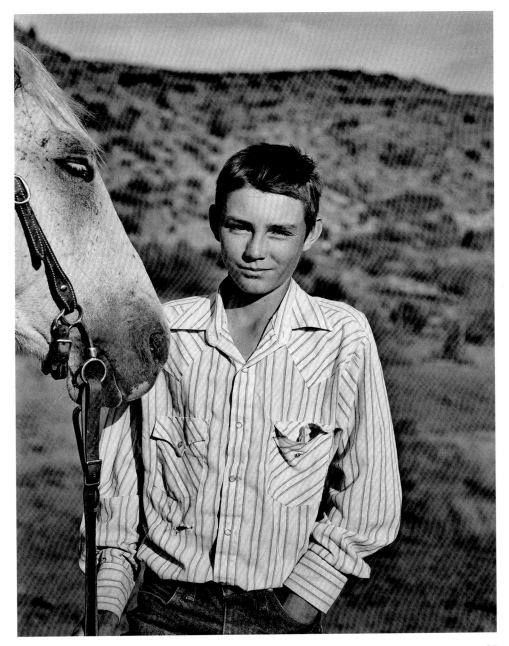

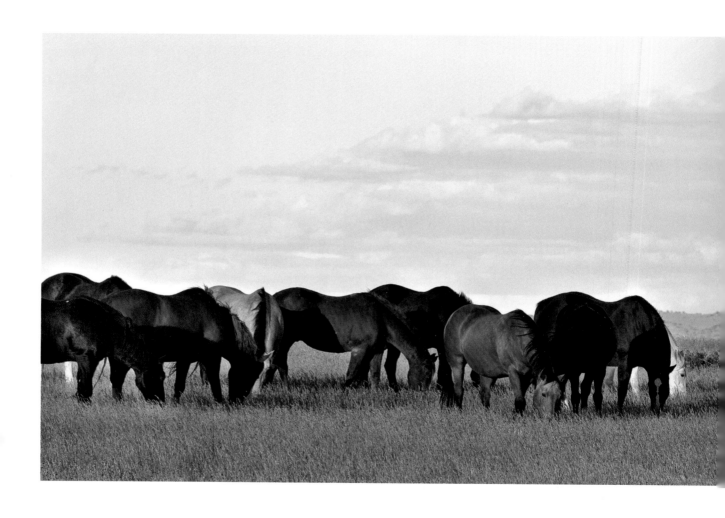

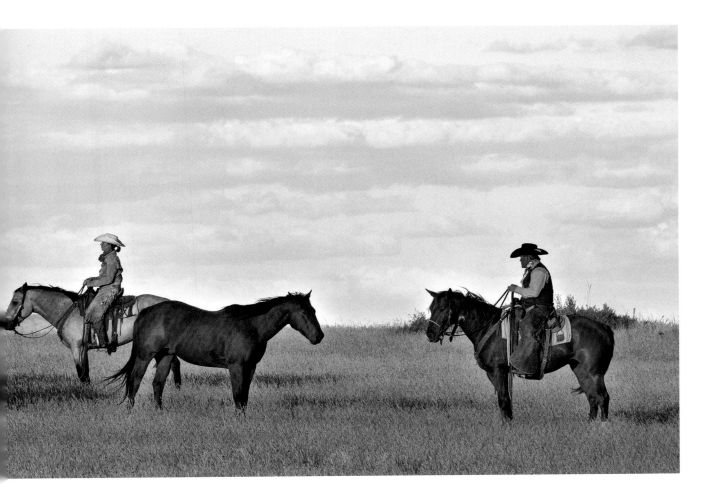

THE REMUDA

Cody Cunningham and his German-born wife, Antonie, survey the remuda at the X Diamond Ranch.
A remuda is a herd from which ranch hands choose their horses. "Antonie can cowboy pretty good," Baxter
says. "She came over to do a high-school exchange for a year and fell in love with the West. A year after
I took this photo, Cody and Antonie welcomed their daughter, Nina Buck Cunningham, into the world."

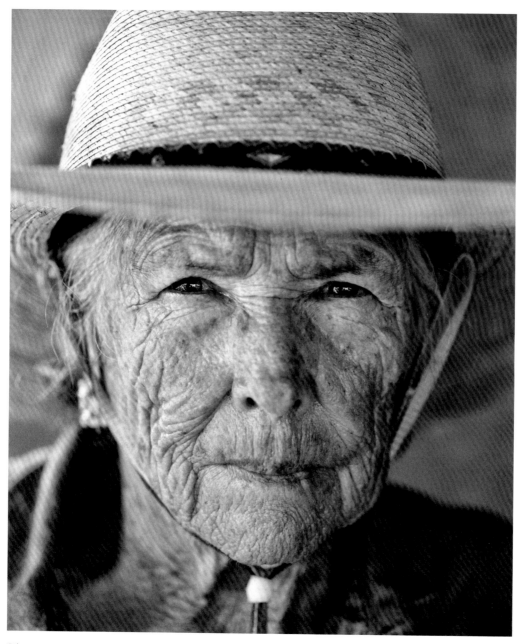

CONNIE BROWN

At 84, Connie Brown of the H4 Ranch in Gila County was "sharp as a tack," Baxter says of when he made this image in 2011. "I was just sitting with Connie talking, as we had been for a while. Sometimes, to get someone to do what you want them to do — look past you — you just make them comfortable. They'll gift that to you, open that up to you, if they feel comfortable. She told me the story of her family, which came from the southern United States. There's so much life in her face."

JOHN LADD

"This was where the original homestead of Ladd's San Jose Ranch was," Baxter says. "It's in Cochise County, southwest of Bisbee. 'The Old House,' they call it."

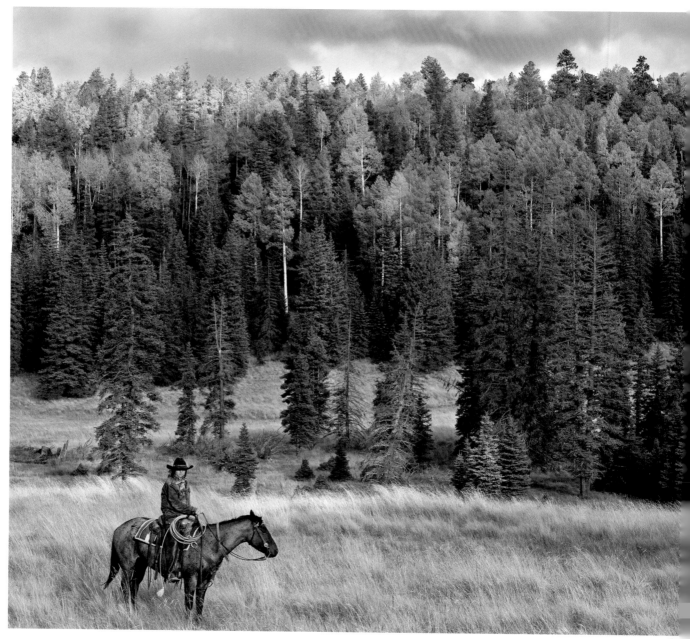

SHOUDI
MAE ESTES

"This is a damn good
cowgirl," Baxter says.
"She was 17 when I
shot this, and I use
her on some of my
workshops. Shoudi
Mae goes to Lamar
College in Colorado,
where she's studying
to be a horse trainer.
She trained up this
horse, Cobalt, and
gets hired to do day
work for ranches
up around Apache
County. We shot this
at 24 Draw at Slade
Ranch, near Greer."

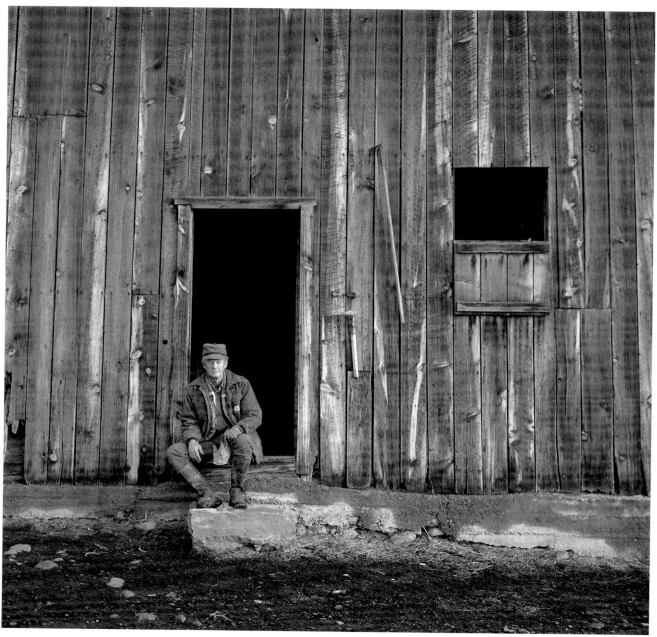

SAM UDALL

Here, Sam Udall (left) wears his irrigating boots and Scotch cap. "This was at Sam's barn at his farm in Eagar," Baxter says. "It's well over 100 years old. Sam had been out in a bunch of mud, and it's one of my favorite photographs of him — it's never been published."

JOHNNY SMALLHOUSE

Johnny Smallhouse (right) was 4 years old when this portrait was made, and he had the utmost adoration for his father, Andy Smallhouse of the Carlink Ranch in Pima County. "Johnny followed me around all day," Baxter says. "He'd watch his dad. At one point, Johnny watched Andy do some very intricate riding — getting ready to sort cattle. Johnny stood next to me on the fence and shouted, 'Dad, that was some pretty good horsebackin'.'"

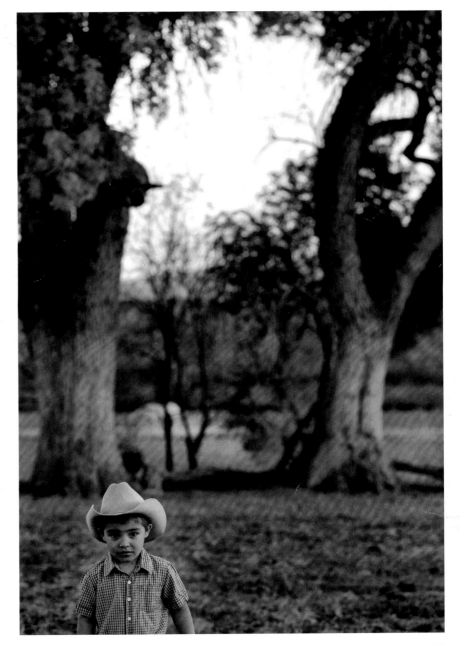

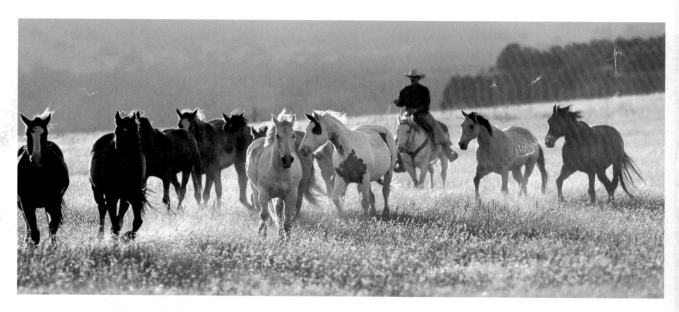

THE REMUDA II

This is the first ranching photograph Baxter shot using color film — Kodachrome. Here, cowboy Fred Colter of the X Diamond Ranch moves the remuda. "This was one of my first times at Schoolhouse Pasture," Baxter says. "It was September 2001. Now, it's my go-to spot, especially when I teach."